# Chairs

LARK

STUDIO SERIES

LARK CRAFTS

A Division of
Sterling Publishing Co., Inc.
New York / London

SENIOR EDITOR
Ray Hemachandra

EDITORS
Julie Hale
Larry Shea

ART DIRECTOR
Chris Bryant

LAYOUT
Skip Wade

COVER DESIGNER
Chris Bryant

FRONT COVER
Lothar Windels
*JOSEPH FELT CHAIR*
PHOTO BY ARTIST

BACK COVER
Peter Danko
*EQUILIBRIUM*
PHOTO BY ANDY FRANCK

Library of Congress Cataloging-in-Publication Data

Lark studio series: chairs / [senior editor, Ray Hemachandra]. — 1st ed.
    p. cm. – (Lark studio series)
  Includes index.
  ISBN 978-1-60059-683-4 (pbk. : alk. paper)
  1. Chairs. 2. Woodwork. I. Hemachandra, Ray. II. Lark Books.
  TT197.5.C45C48 2010
  749'.32—dc22

                                    2010004951

10 9 8 7 6 5 4 3 2 1

First Edition

Published by Lark Books, A Division of
Sterling Publishing Co., Inc.
387 Park Avenue South, New York, NY 10016

Text © 2010, Lark Books, A Division of Sterling Publishing Co., Inc.
The work in this book appeared in *500 Chairs*, juried by Craig Nutt.

Photography © 2010, Artist/Photographer

Distributed in Canada by Sterling Publishing,
c/o Canadian Manda Group, 165 Dufferin Street
Toronto, Ontario, Canada M6K 3H6

Distributed in the United Kingdom by GMC Distribution Services,
Castle Place, 166 High Street, Lewes, East Sussex, England BN7 1XU

Distributed in Australia by Capricorn Link (Australia) Pty Ltd.,
P.O. Box 704, Windsor, NSW 2756 Australia

If you have questions or comments about this book, please contact:
LARK CRAFTS | 67 Broadway | Asheville, NC 28801 | 828-253-0467

Manufactured in China

ISBN 13: 978-1-60059-683-4

For information about special sales, contact the Sterling Special Sales Department at
800-805-5489 or specialsales@sterlingpub.com.

# CONTENTS

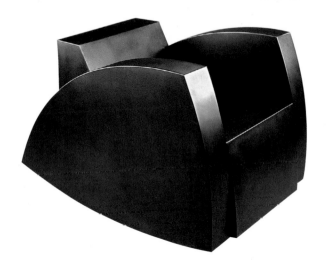

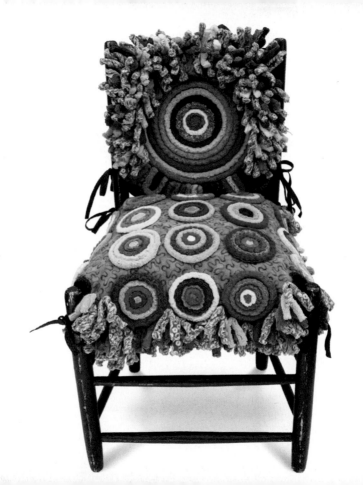

# INTRODUCTION

The Lark Studio Series is designed to give you an insider's
look at some of the most exciting work being made by
artists today. The chairs we've selected demonstrate
fine traditional craftsmanship, modern invention, or
exciting—and sometimes startling—combinations
of the two. We include furniture by the world's
leading makers and by amateur visionaries.
Before you turn the page and journey through
this collection, please: Have a seat!

Paul Reiber

## SUN'S HANDS
61 x 24 x 18 inches (153 x 64 x 46 cm)

Cherry, walnut, gold leaf, fabric

PHOTO BY JESS SHIRLEY

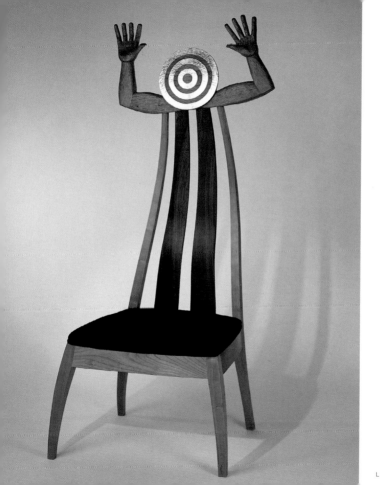

Dean Pulver

**MY FRIEND**
32 x 27 x 26 inches (80 x 68 x 65 cm)

Dyed walnut

PHOTO BY PAT POLLARD

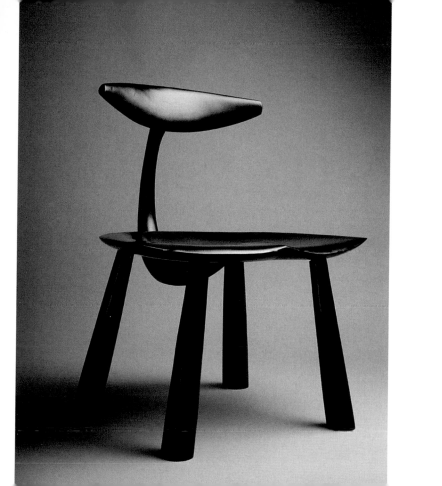

Sam Maloof

**ROCKER**

PHOTO COURTESY OF SAM MALOOF

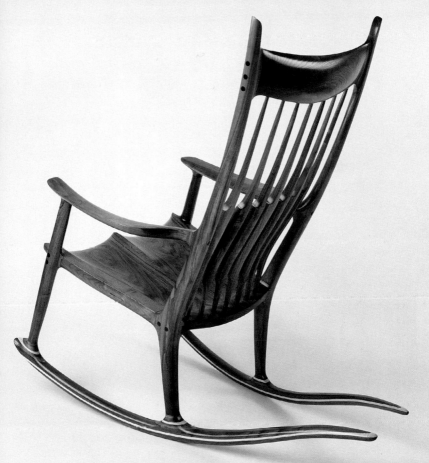

Peter Danko

## EQUILIBRIUM
33 x 23 x 27 inches (84 x 58 x 69 cm)

Ply-bent beech, seat-belt material

PHOTO BY ANDY FRANCK

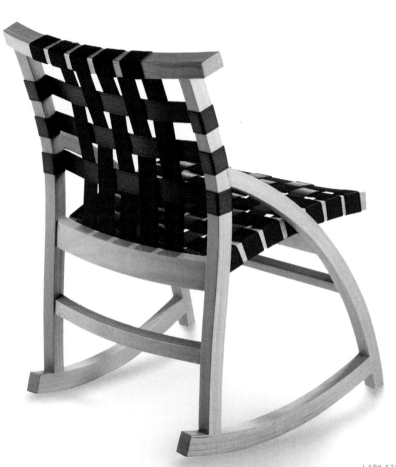

Craig Nutt

## CELERY CHAIR WITH PEPPERS, CARROTS & SNOW PEAS

37 x 25 x 22 inches (93 x 63 x 55 cm)

Wood, leather, lacquer

PHOTO BY DEBORAH WIYGUL

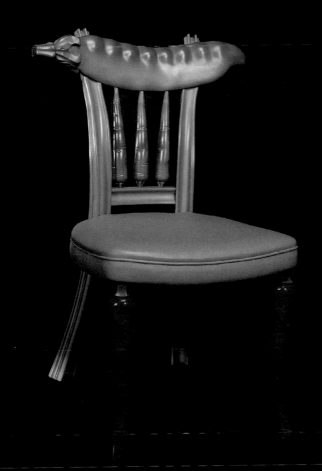

Jon Brooks

## TRUE LOVES BLUE
52 x 52 x 28 inches (130 x 130 x 70 cm)

Maple, acrylic, color pencil, stain, lacquer, varnish

PHOTO BY DEAN POWELL
COURTESY OF CURRIER MUSEUM OF ART

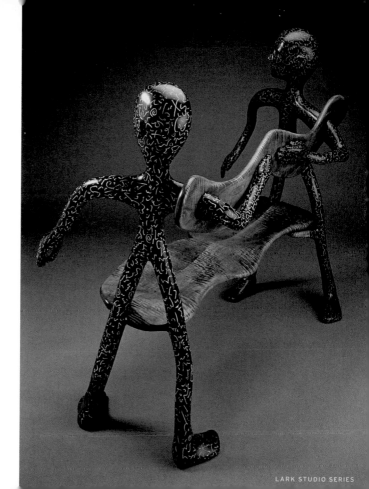

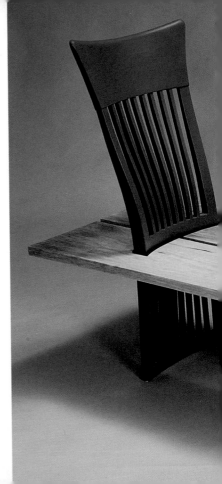

Rachel Avivi

# PAIR CHAIR
39 x 60 x 25 inches (98 x 150 x 63 cm)

Walnut, wood backrests, oil paint

PHOTO BY REUVEN MARTON

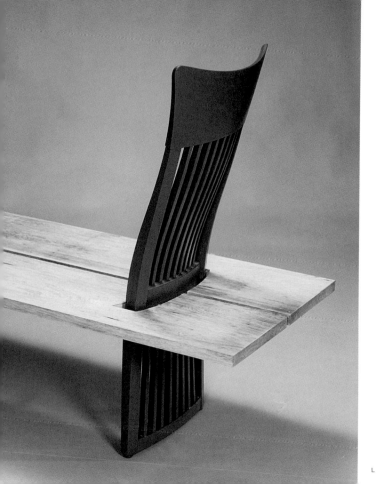

Cameron Van Dyke

## DR. STARR
36 x 46 x 33 inches (90 x 115 x 83 cm)

Steel, leather

PHOTO BY SHIPPERT

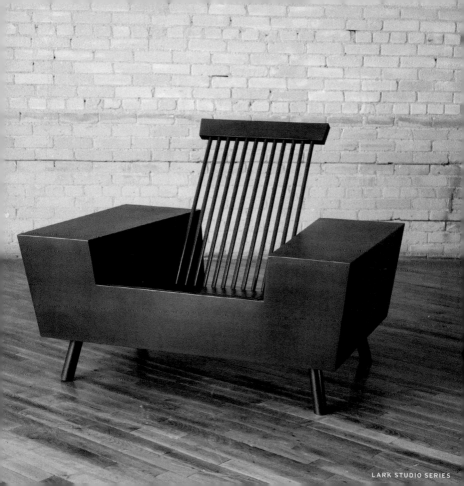

J. Michael Floyd

## ADIRONDACK 20/20
42 x 32 x 44 inches (105 x 80 x 110 cm)

Bubinga veneer, painted plywood

PHOTOS BY JOHN LUCAS

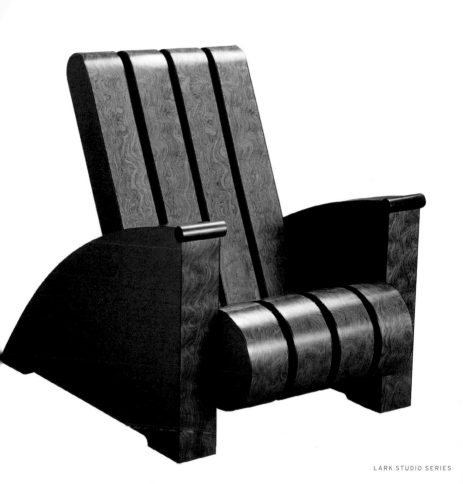

Katherine Ortega

## SLIPPER CHAIR
49 x 26 x 37 inches (123 x 65 x 93 cm)

Poplar, painted maple, upholstery

PHOTO BY ARTIST

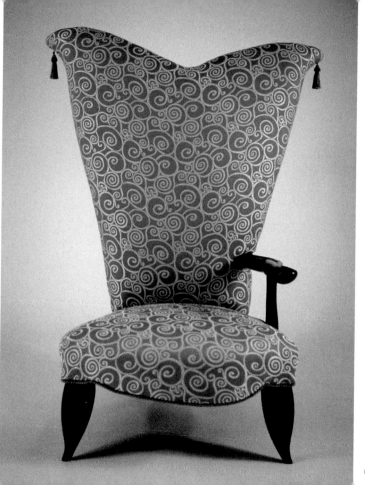

Rob Millard-Mendez

# ICARUS CHAIR
14 x 10 x 20 inches (36 x 25 x 51 cm)

Wood, steel, wax

PHOTO BY JOHN MACIEL

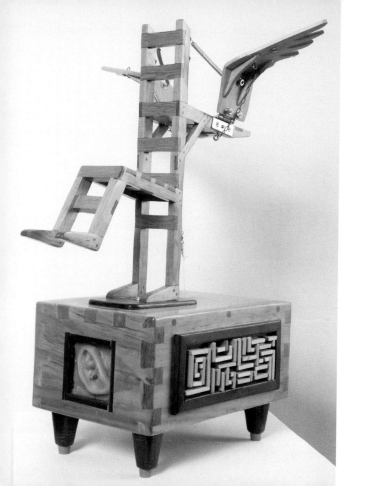

Kimberly Winkle

# CHILDREN'S YELLOW FACETED CHAIR

26 x 14 x 15 inches (66 x 36 x 38 cm)

Mahogany, poplar, graphite

PHOTOS BY JOHN LUCAS

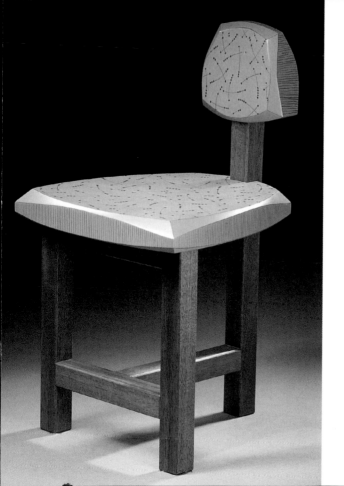

Jack Larimore

## NATURAL DESIRE
Each: 54 x 24 x 24 inches (135 x 60 x 60 cm)

Paulownia, ash, bronze, felt

PHOTOS BY JOHN CARLANO

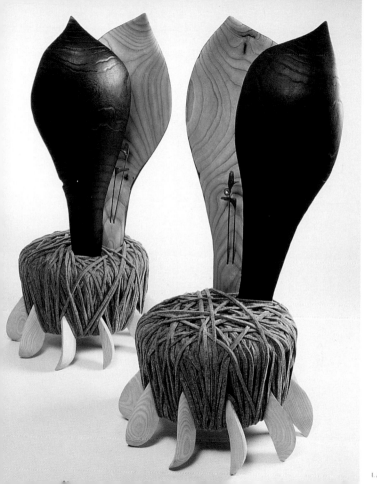

Judiyaba Olivier
Rufus Olivier

## OPUS 00
49 x 11 x 24 inches (123 x 28 x 60 cm)

Wood, acrylic and latex paint

PHOTOS BY KRISTIN HALGEDAHL

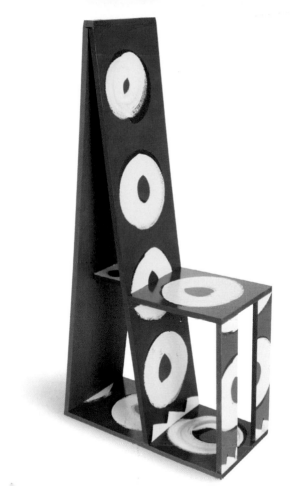

Dennis P. Schlentz

## QUEEN'S CHAIR
50 x 24 x 23 inches (125 x 61 x 58 cm)

Pau amarelo wood, stained glass, leather

PHOTO BY JOHN LAWS (JL IMAGING)

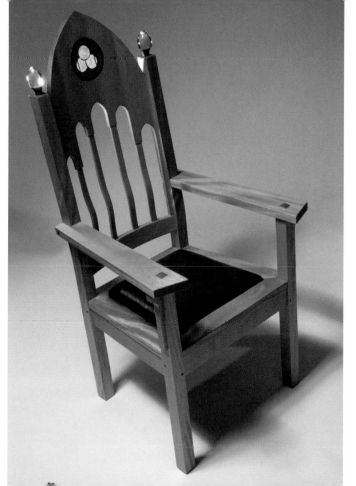

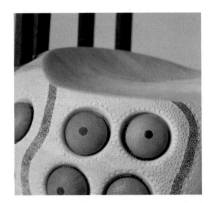

Ross Annels

# ECHINOID CHAIR
72 x 20 x 21 inches (180 x 51 x 53 cm)

Silver ash, jarrah, silky oak

PHOTO BY GEOFF POTTER
DETAIL PHOTO BY ANDREA HIGGINS

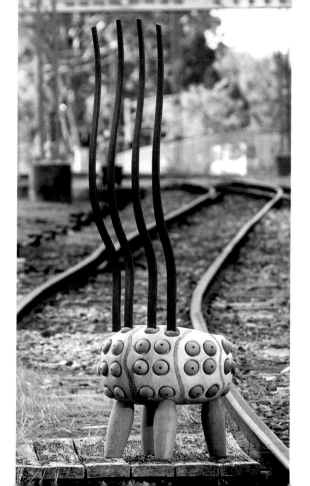

Michael Gloor

## WINDOW CHAIR I
42 x 17 x 16 inches (105 x 43 x 41 cm)

Mahogany frame, African satinwood, leather

PHOTO BY DAVID GILSTEIN

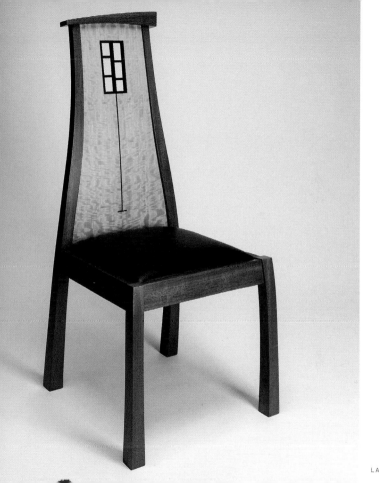

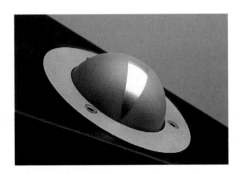

Taeyoul Ryu

## **BLACK CAT**
72 x 18 x 47 inches (180 x 46 x 118 cm)

Poplar, plywood, aluminum, leather

PHOTOS BY SYLVIA L. ROSEN

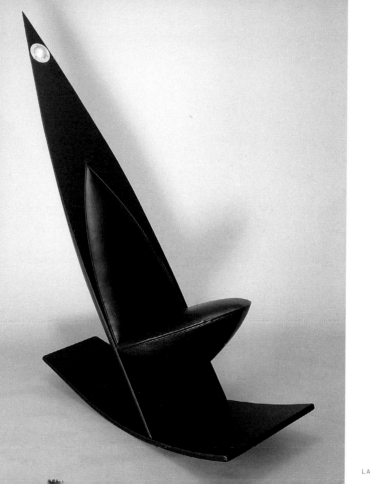

## Marcus Papay

# CATAPULT
16 x 48 x 20 inches (41 x 120 x 51 cm)

Ash, steel cable, steel sheet

PHOTOS BY LARRY STANLEY

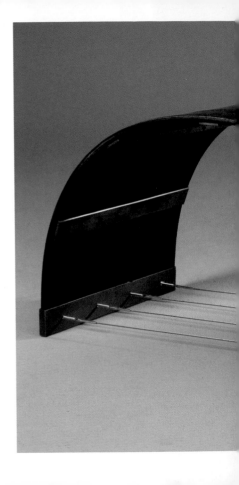

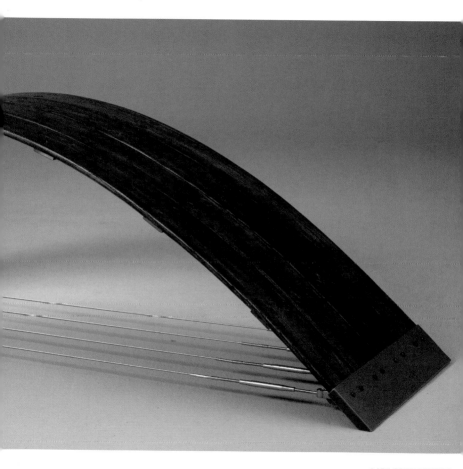

Matthew E. Nauman

## ADIRONDACK
42 x 24 x 24 inches (105 x 60 x 60 cm)

Red oak, sassafras

PHOTO BY ROY ENGELBRECHT

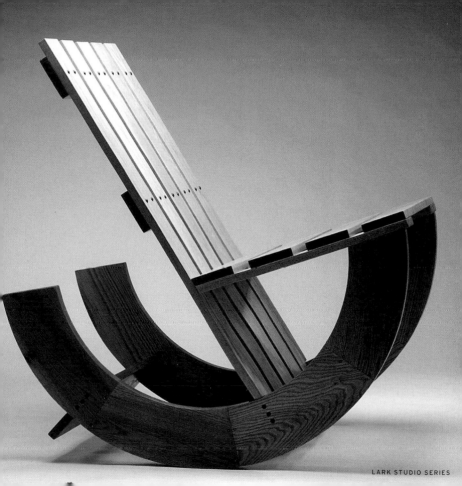

Karen DeLuca

# UNTITLED

15 x 14 x 32 inches (38 x 36 x 80 cm)

Plywood, earplugs, acrylic paint

PHOTOS BY CHARLES DELUCA

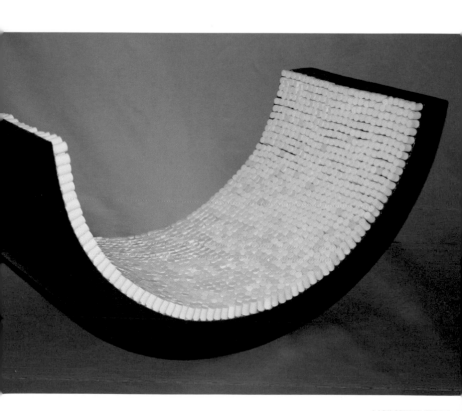

Trenton Baylor

## STUMP

30 x 24 x 24 inches (75 x 61 x 61 cm)

Mahogany, cast bronze

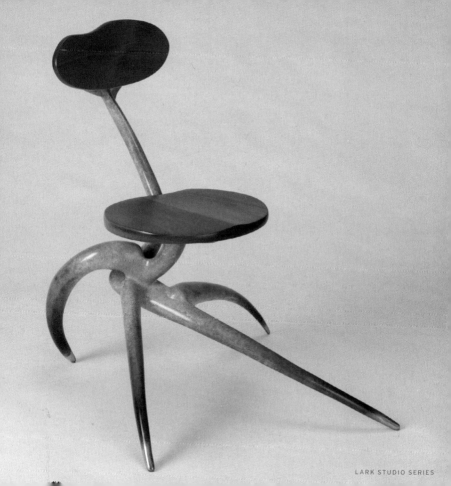

Dale Lewis

## GASTROPODAFEMME
70 x 29 x 31 inches (175 x 73 x 78 cm)

Dyed and natural ash, maple,
cherry, rosewood, holly, ebony

PHOTO BY RALPH ANDERSON

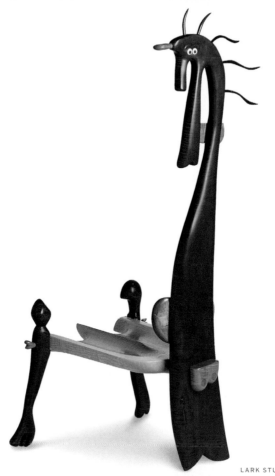

Andrew Muggleton

# BALUSTRADE CHAISE
31 x 20 x 59 inches (78 x 51 x 148 cm)

Wenge, mahogany, aluminum rails, suede

PHOTO BY DEAN POWELL

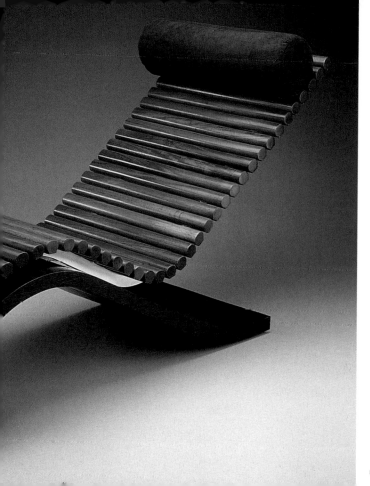

John Clark

## MOON CHAIR
Each: 42 x 18 x 19 inches (107 x 46 x 48 cm)

Mahogany, quilted maple, ebony

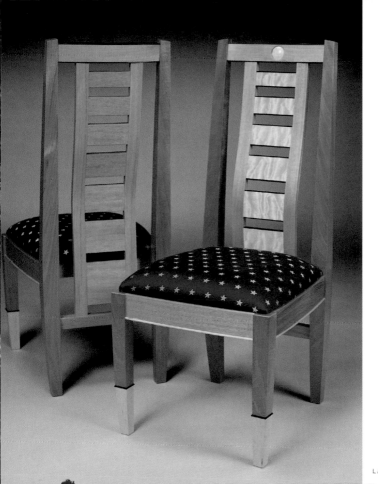

Carolyn Grew-Sheridan

## READER'S CHAIR
47 x 45 x 35 inches (118 x 113 x 88 cm)

Maple, maple plywood, paint

PHOTO BY JOE SCHOPPLEIN

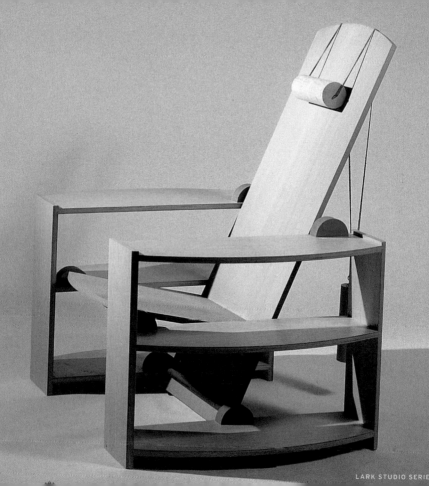

Ruth Fore

## VROOM
26 x 22 x 36 inches (66 x 56 x 90 cm)

Plywood, steel

PHOTO BY TUAN NYUGEN

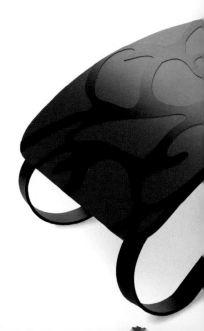

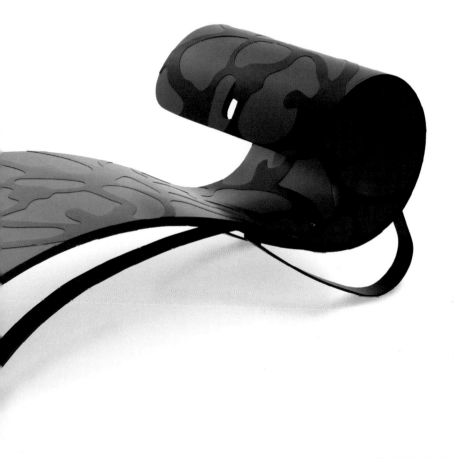

Michael Singer

## **SERENGETI CHAIR**
42 x 20 x 24 inches (105 x 51 x 61 cm)

Curly maple, cocobolo, leather

PHOTO BY ARTIST

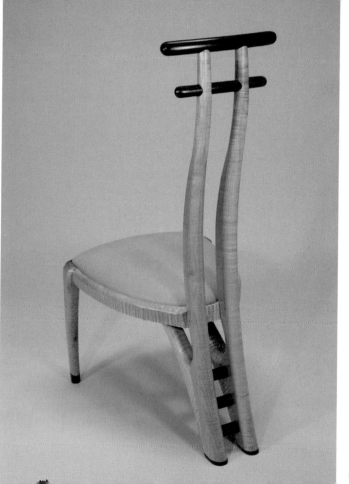

Graham Campbell

## ROSINANTE
24 x 17 x 72 inches (61 x 43 x 180 cm)

Medium-density fiberboard, cherry, paint

PHOTO BY JOHN LUCAS

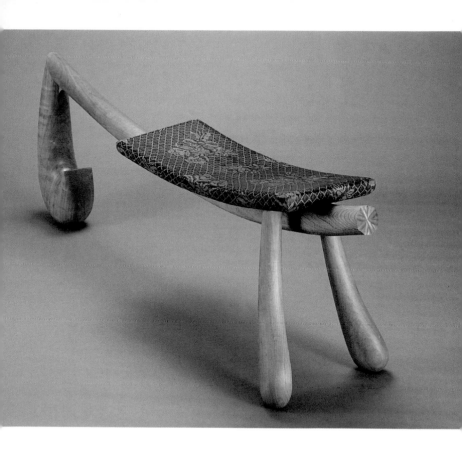

B.G. Pelcak

# EVE 6
27 x 16 x 28 inches (69 x 41 x 71 cm)

Birch plywood, moradillo

PHOTO BY JAY CHIU

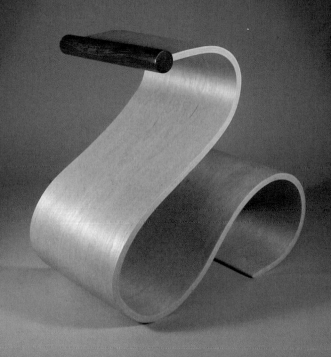

Edward Henderson

## UNTITLED
80 x 13 x 15 inches (200 x 33 x 38 cm)

Wood, canvas, oil paint

PHOTOS BY GARY GRAVES

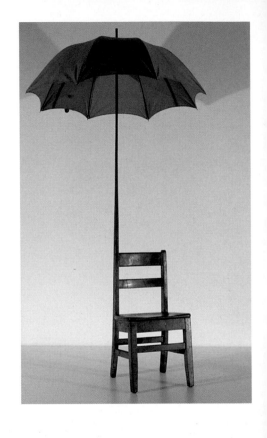

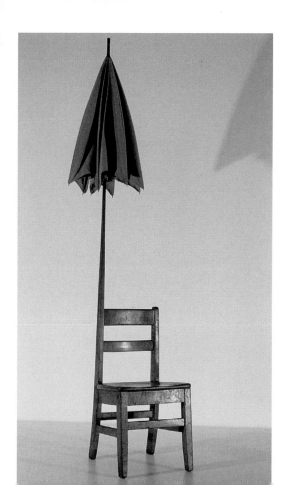

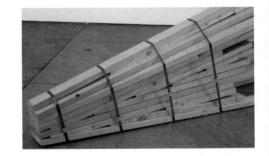

Nikolai Moderbacher

# 2 X 4 STRAPPED
50 x 41 x 130 inches (125 x 103 x 325 cm)

Wood, strapping

PHOTOS BY ARTIST

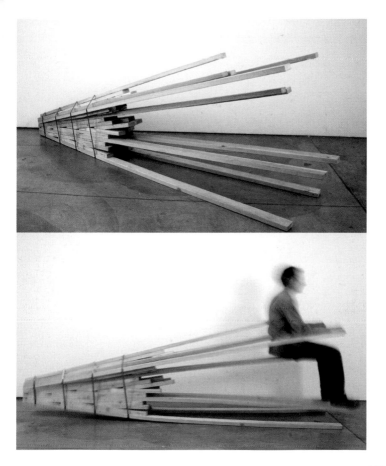

Lothar Windels

## JOSEPH FELT CHAIR

32 x 44 x 36 inches (80 x 110 x 90 cm)

Stainless steel, wool felt

PHOTO BY ARTIST

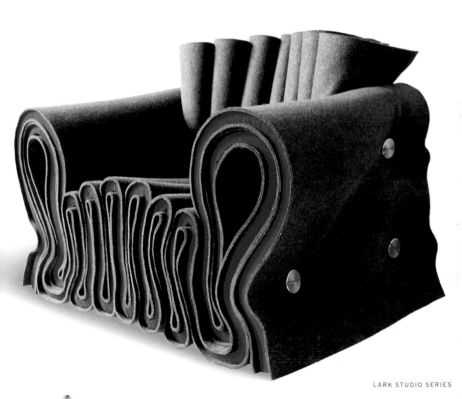

Robert Spangler

## DOIG BENCH
26 x 60 x 16 inches (66 x 150 x 40 cm)

Oregon walnut

PHOTO BY MARK VAN S.

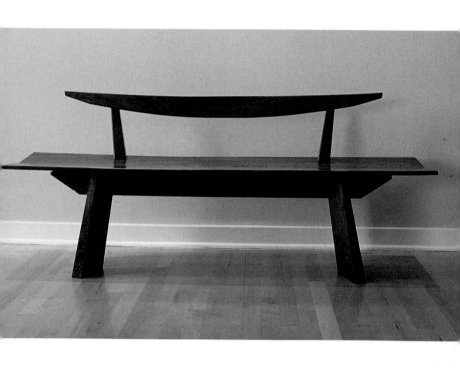

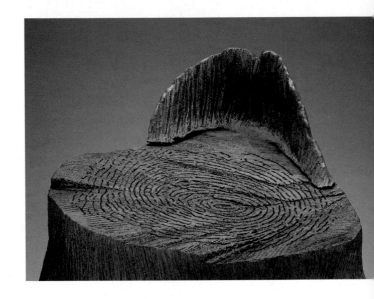

Ted Vogel

# CAMPFIRE STORIES–STUMP STOOL
28 x 22 x 22 inches (71 x 56 x 56 cm)

Clay

PHOTOS BY BILL BACHHUBER

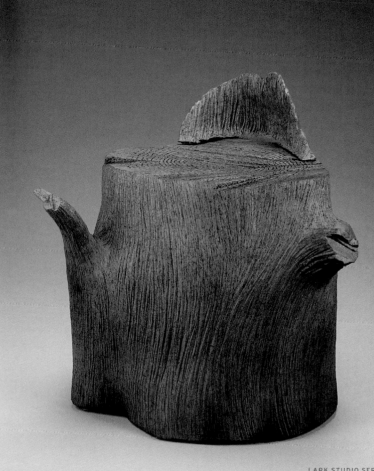

Rosario Mercado

## **PILLOW CHAIR**
38 x 23 x 27 inches (95 x 58 x 69 cm)

Wood, down, cotton

PHOTO BY ARTIST

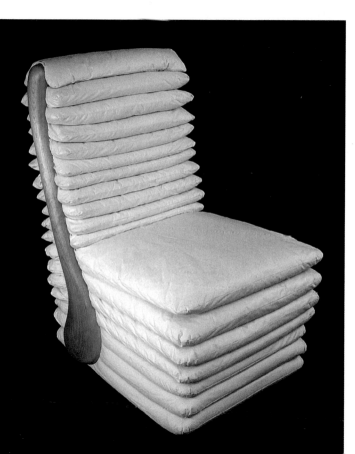

Sylvie Rosenthal

## THE ANGEL OF DEATH, DISGUISED AS A PARK BENCH

54 x 16 x 27 inches (135 x 41 x 69 cm)

Mahogany, steel

PHOTO BY ARTIST

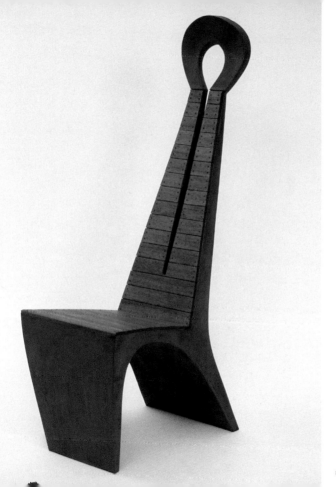

Christopher Poehlmann

## RED ROCKER
40 x 24 x 48 inches (100 x 61 x 120 cm)

Aluminum, paint

PHOTO BY ED CHAPPELL

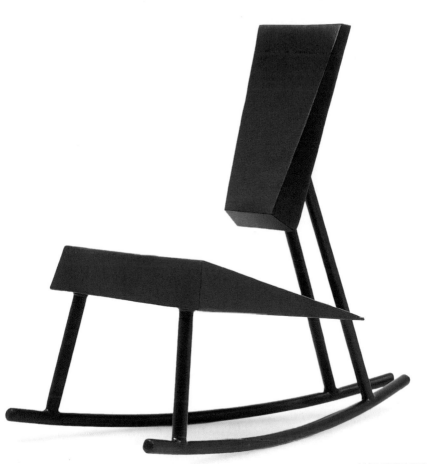

Paul Freundt

## SWEPT BACK CHAIR
36 x 30 x 25 inches (90 x 75 x 64 cm)

Stainless steel

PHOTO BY BRYAN MOREHEAD

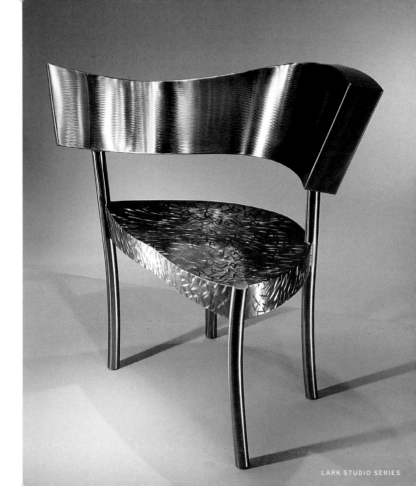

Clay Dillard

## TULIP FOLDING CHAIR
Each: 35 x 18 x 9 inches (88 x 46 x 23 cm)

Stainless steel, aluminum

PHOTO BY POP GUN PHOTOGRAPHY

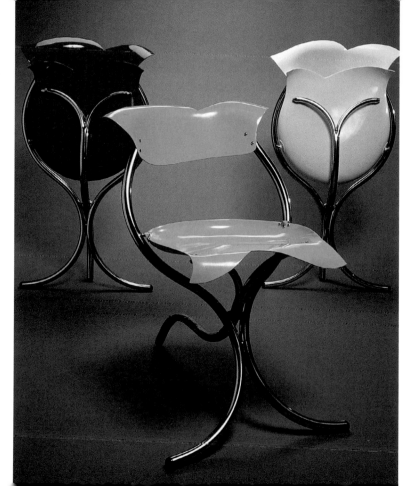

Judy Kensley McKie

## MONKEY CHAIR
36 x 25 x 25 inches (90 x 64 x 64 cm)

Walnut, bronze

PHOTOS BY SCOTT MCCUE

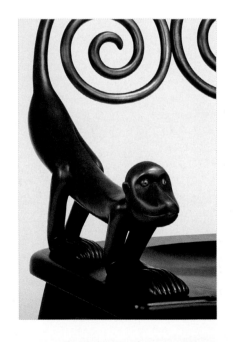

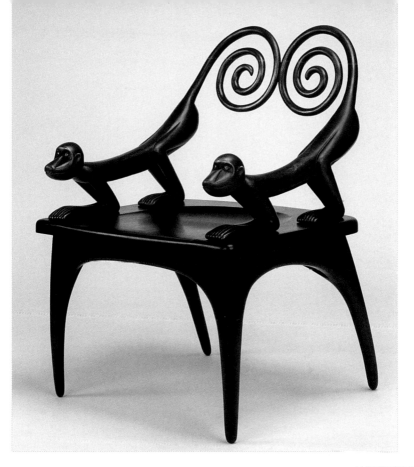

David W. Scott

# LOW BACK RIPPLE STOOL
34 x 20 x 20 inches (85 x 51 x 51 cm)

Maple, milk paint

PHOTO BY TIM BARNWELL

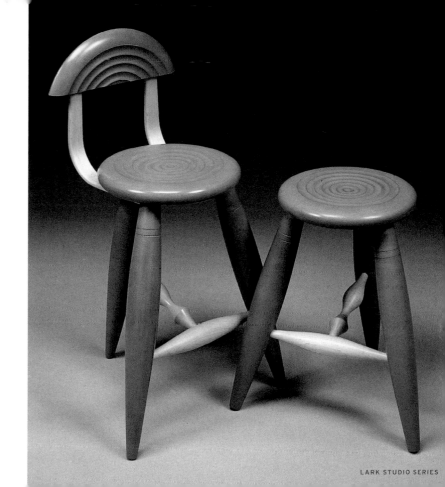

Jordan Gehman

# LOW RIDER
30 x 16 x 46 inches (75 x 41 x 115 cm)

Maple, bleached maple

PHOTO BY LARRY STANLEY

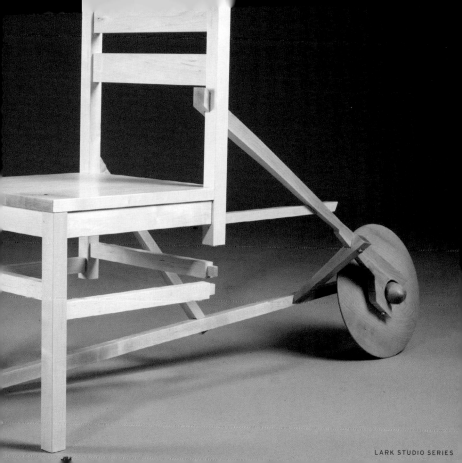

Susan Broidy

# BODY CHAIR 2
37 x 18 x 24 inches (93 x 46 x 61 cm)

Plywood

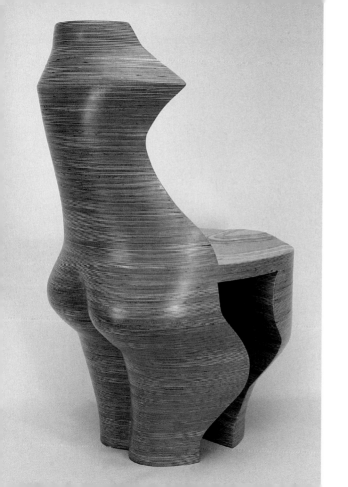

Johnny Whyte

## **COCKFIGHT**
42 x 57 x 23 inches (105 x 143 x 58 cm)

Claro walnut, Chinese elm burl

PHOTO BY ARTIST

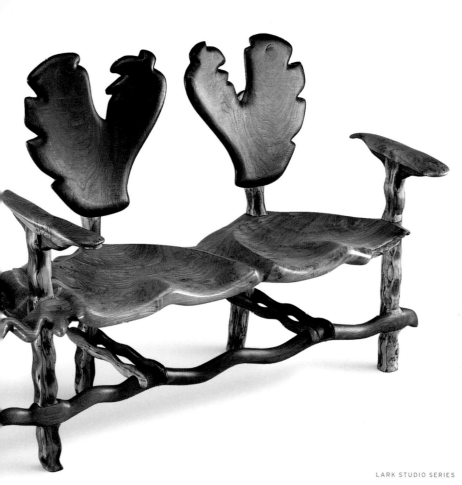

Brad Reed Nelson

## THE CULT OF CHARLES AND RAY
24 x 24 x 34 inches (61 x 61 x 85 cm)

Cherry, steel, aluminum, skate wheels, wool

PHOTO BY ALAN MCCOY

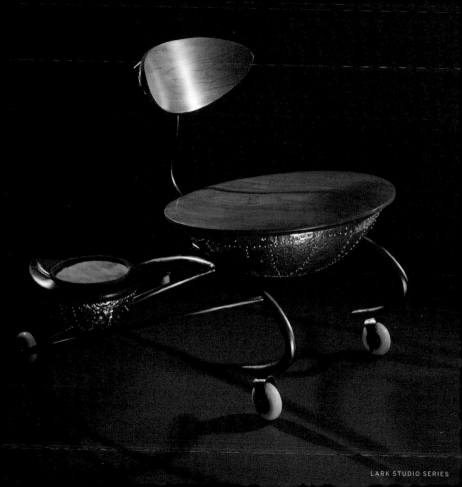

Gregg Lipton

# UNTITLED
Each: 36 x 18 x 18 inches (91 x 46 x 46 cm)

Bleached ash

PHOTO BY STRETCH TUEMMLER

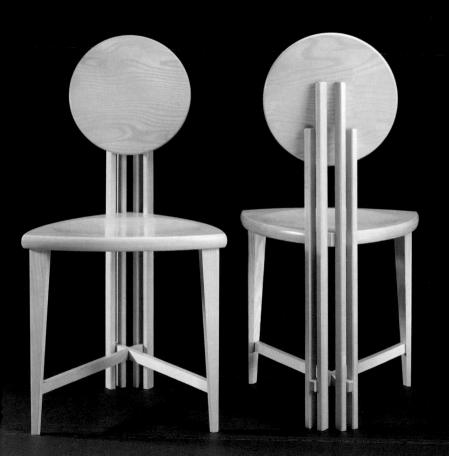

Miles Epstein

## SF WHEEL CHAIR
52 x 26 x 28 inches (130 x 65 x 70 cm)

Wine corks, cardboard, scrap copper, leather

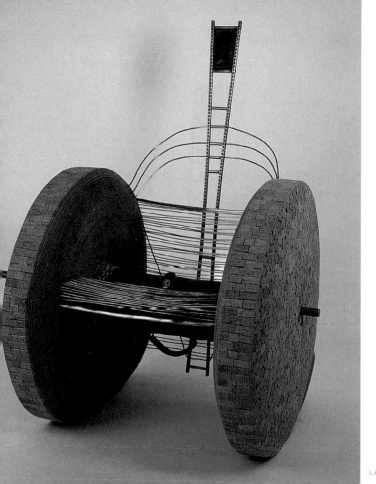

Chris M. Todd

**TIPPYTOES**
57 x 10 x 13 inches (143 x 25 x 33 cm)

Mahogany, foam, paper pulp, resin

PHOTO BY EDEN REINER

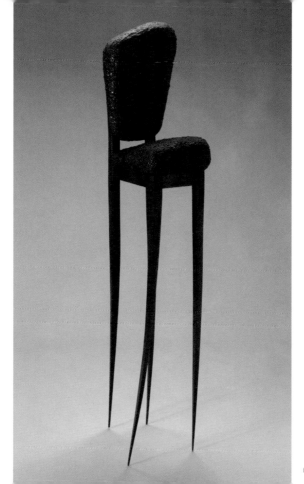

Kerry Vesper

## KAA CHINI
40 x 39 x 35 inches (100 x 98 x 88 cm)

Baltic birch, wenge

PHOTOS BY RON DERIEMACKER

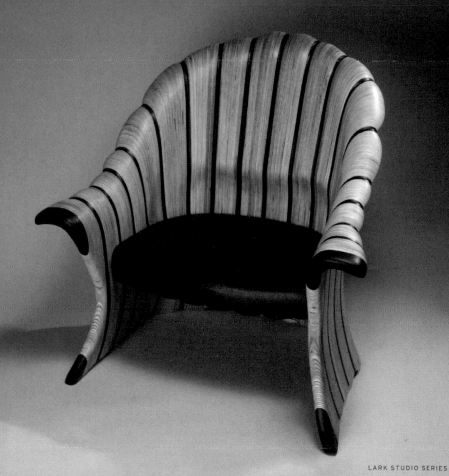

Bonnie Bishoff
J.M. Syron

## STAR CHAIR
30 x 23 x 30 inches (75 x 58 x 75 cm)

Cherry, polymer clay veneer, faux leather

PHOTOS BY DEAN POWELL

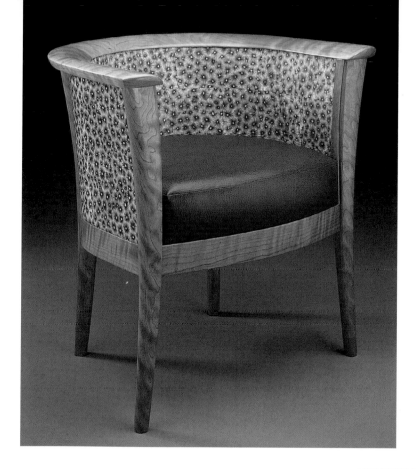

Joel Green

**LIVING LOUNGE**
30 x 96 x 38 inches (75 x 240 x 95 cm)

Poplar, fiberglass, microsuede

PHOTO BY MARK JOHNSTON

Neil Erasmus

# KAMA SEATRA
31 x 16 x 62 inches (78 x 41 x 155 cm)

Oak veneer, paulownia, stainless steel

PHOTOS BY ROBERT GARVEY

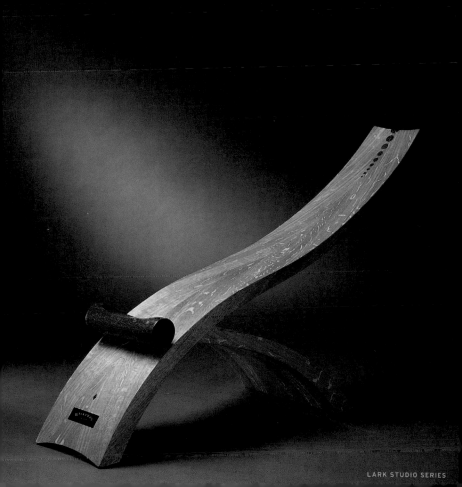

Vincent Robles

## TRESTLE CHAIR #1
36 x 30 x 13 inches (90 x 75 x 33 cm)

Dyed ash

PHOTO BY LARRY STANLEY

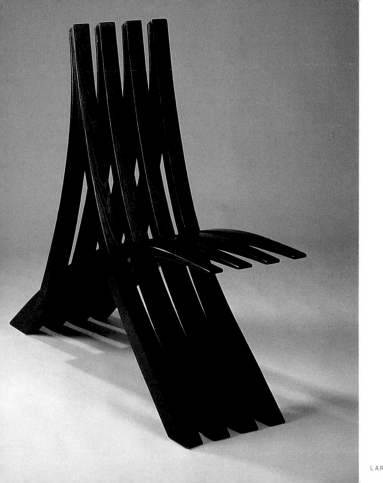

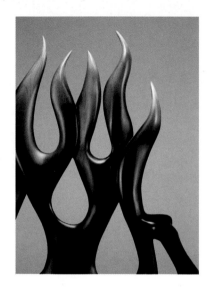

Chad Aldridge

# FLAME ON!
50 x 30 x 34 inches (125 x 75 x 85 cm)

Cherry, patina

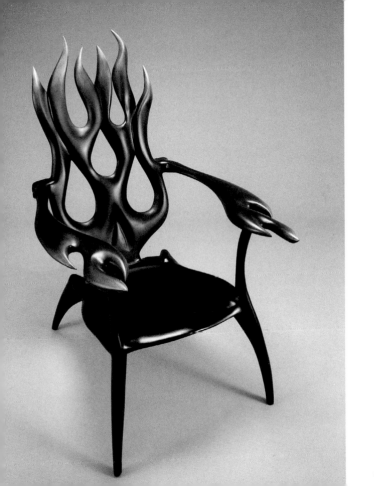

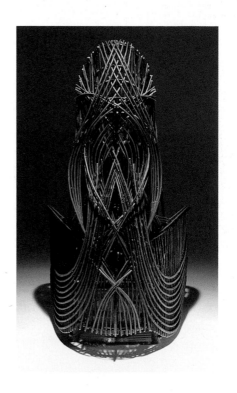

Clifton Monteith

# RENWICK TALL CHAIR
46 x 30 x 30 inches (115 x 75 x 75 cm)

Willow, aspen

PHOTOS BY JOHN WILLIAMS

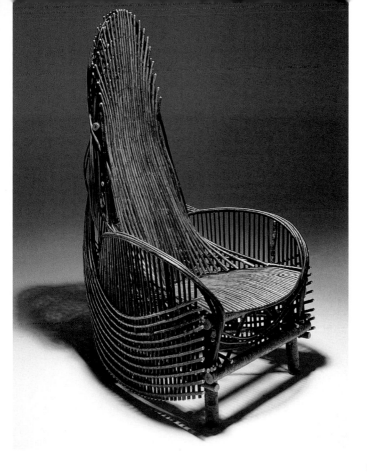

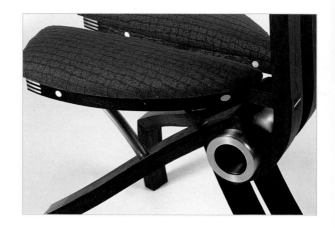

Pavel P. Peřina

# CHAIR MARILYN
43 x 18 x 22 inches (108 x 46 x 56 cm)

Jarrah, aluminum, upholstery

PHOTOS BY EDDIE RESERA

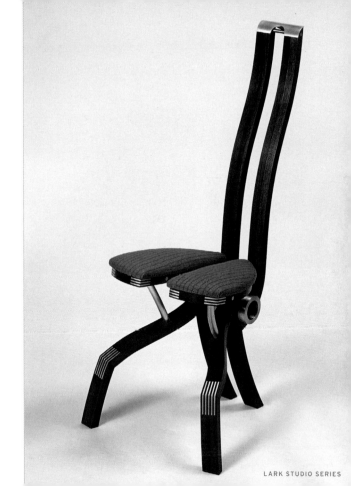

LARK STUDIO SERIES

Kim Kelzer

# LAP DANCE CHAIR
30 x 23 x 18 inches (75 x 58 x 46 cm)

Maple, leather, found objects, fake fur

PHOTOS BY RACHEL OLSSEN

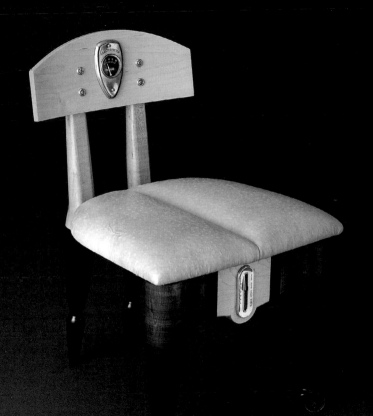

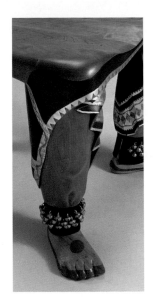

Sabiha Mujtaba

# BHARATANATYAM DANCER
41 x 27 x 24 inches (103 x 68 x 62 cm)

Cherry, polychrome, transfer gold leaf, bells

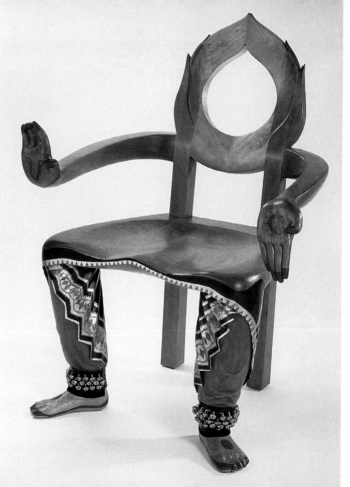

Jonathan Delp

# REJECTION OF TRADITION

30 x 25 x 30 inches (75 x 64 x 75 cm)

Mahogany, canary wood, upholstery

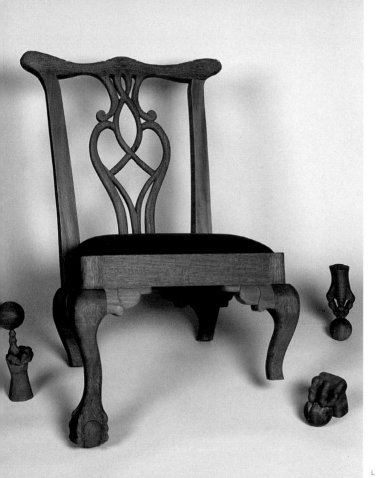

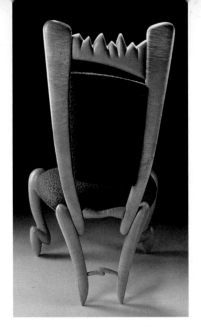

Karen Ernst

## QUANDARY MOUNTAIN DINING CHAIR
40 x 22 x 24 inches (100 x 56 x 61 cm)

Maple, fabric, foam

PHOTOS BY MARK JOHNSTON

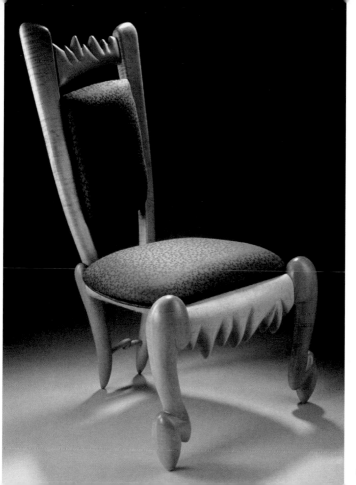

Richard Bronk

# UNTITLED

35 x 57 x 24 inches (88 x 143 x 60 cm)

Bird's eye maple, Honduran and
African mahogany, wenge, curly maple

PHOTO BY BILL LEMKE

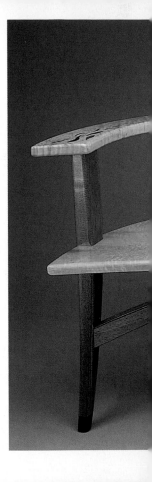

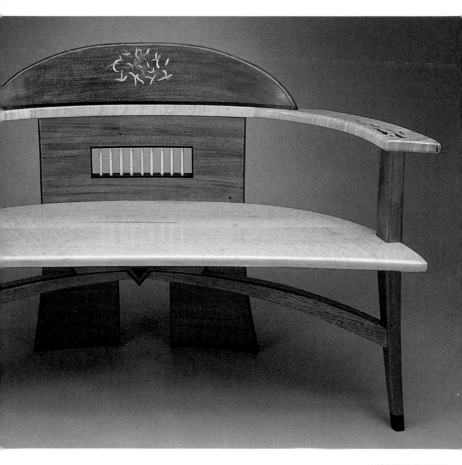

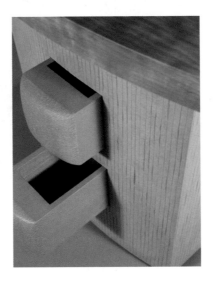

Chris Bowman

## CHAIR WITH DRAWERS
41 x 18 x 17 inches (103 x 46 x 43 cm)

Cherry, birch veneer plywood, milk paint

PHOTOS BY ARTIST
COURTESY OF TERCERA GALLERY

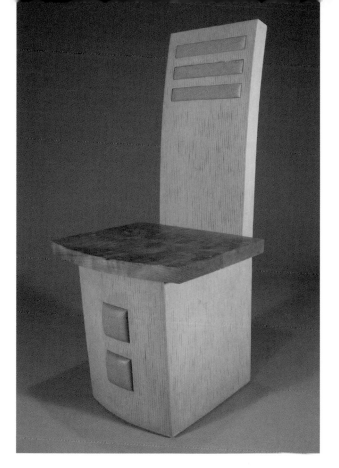

Steven T. Samson

# ME, MYSELF AND I
53 x 25 x 20 inches (133 x 64 x 51 cm)

Mahogany, basswood, milk paint,
acrylic, brass, found object, fabric

PHOTO BY JEFFREY L. MEEYWSEN
COURTESY OF KENDALL COLLEGE OF ART AND DESIGN

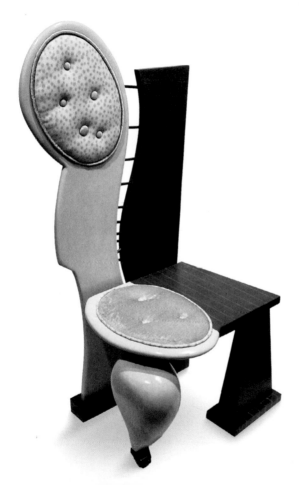

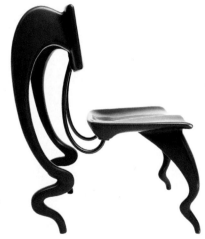

Dean Wilson

## UNTITLED
34 x 20 x 26 inches (86 x 51 x 66 cm)

Fiberglass, foam, painted steel

PHOTOS BY ARTIST

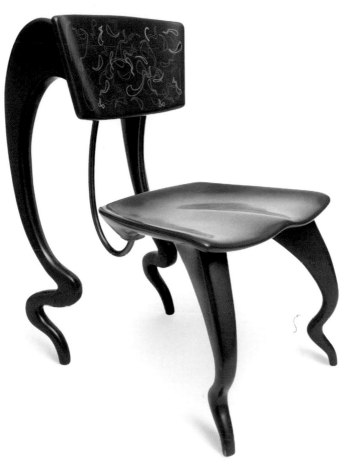

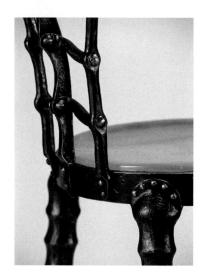

Chris Shea

# CAFÉ CHAIRS
Each: 36 x 17 x 17 inches (90 x 43 x 43 cm)

Steel, glass

PHOTOS BY JOHN LUCAS
COURTESY OF WEXLER GALLERY

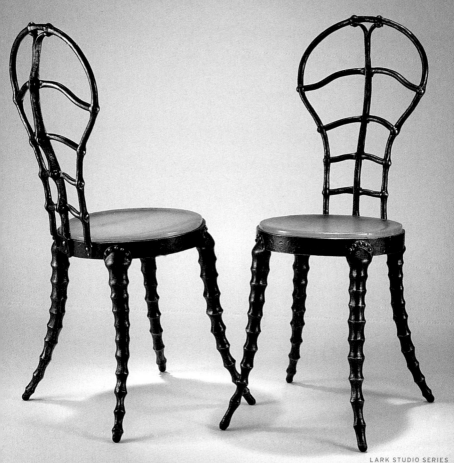

Chajo

## **BOWED GAME CHAIR**
44 x 16 x 16 inches (110 x 41 x 41 cm)

Maple, steel

PHOTO BY HAP SAKWA

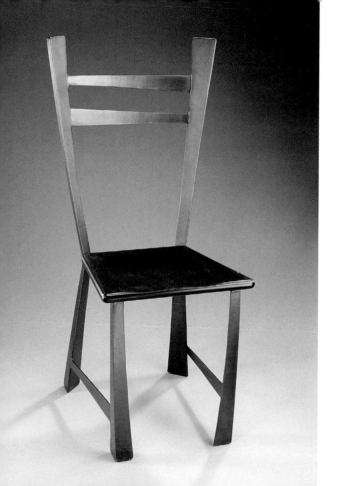

Peter Diepenbrock

# WASHER CHAIR #3
48 x 48 x 48 inches (120 x 120 x 120 cm)

Stainless steel

PHOTOS BY ARTIST

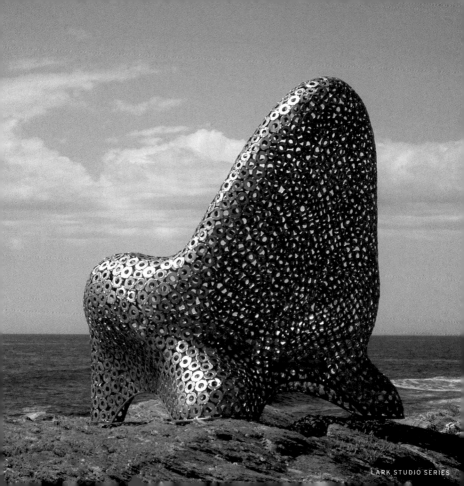

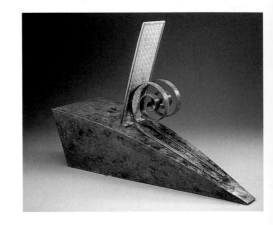

Mitch Ryerson

## SUMMER CHAIR
40 x 24 x 48 inches (100 x 61 x 120 cm)

Marine plywood, copper, aluminum

PHOTOS BY DEAN POWELL

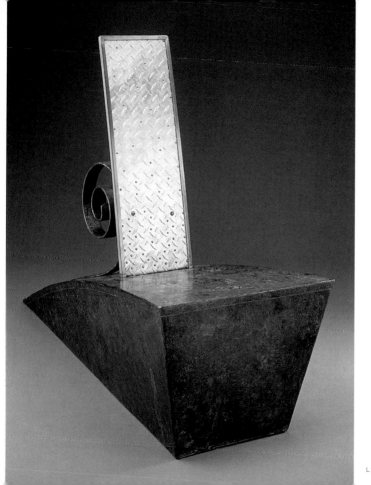

Robb Helmkamp

## LOTUS MEDITATION CHAIR
20 x 30 x 28 inches (50 x 75 x 71 cm)

Walnut, maple, laminated door skins

PHOTOS BY ARTIST

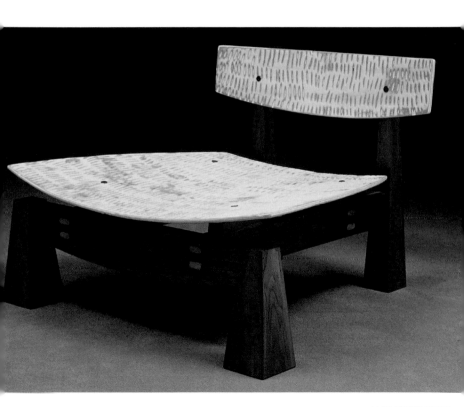

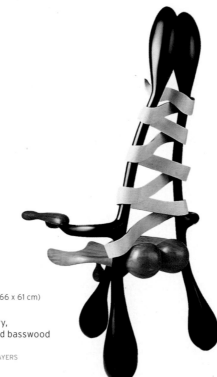

Lepo

**UNTITLED**
59 x 26 x 24 inches (148 x 66 x 61 cm)

Pickled maple, cherry,
cocobolo, ebonized basswood

PHOTOS BY MICHAEL AYERS

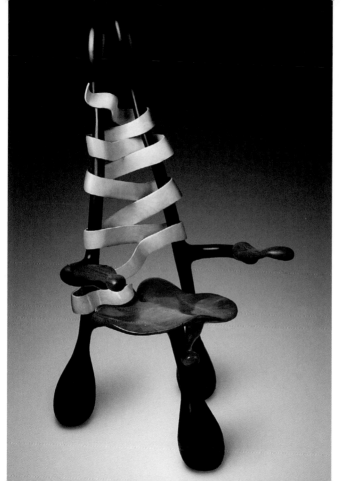

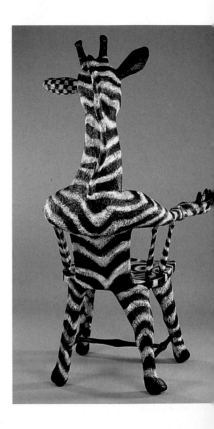

Rhea Giffin

# DALI'S DARLIN' ZIRAFFE

56 x 32 x 26 inches (140 x 80 x 65 cm)

Wood chair, cellulose insulation,
wheat paste, paper, plaster cloth,
insulation foam, acrylic paint, polyurethane

PHOTOS BY S. JOSEPH SHARNETSKY

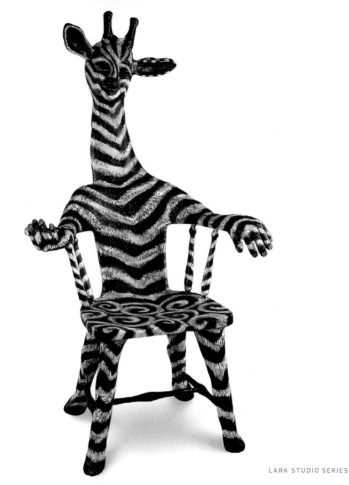

David M. Grosz

# PEGASUS
70 x 85 x 86 inches (175 x 213 x 215 cm)

Solid wood, deerskin, metals

PHOTOS BY ARTIST

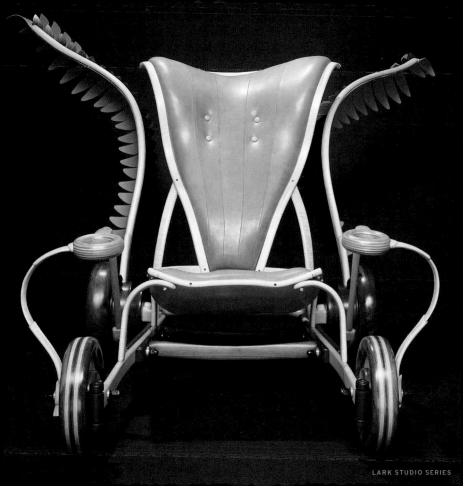

Connie Levathes

# UNTITLED

43 x 39 x 27 inches (108 x 98 x 69 cm)

Glass tile mosaic, recycled styrofoam, cement, fiberglass mesh

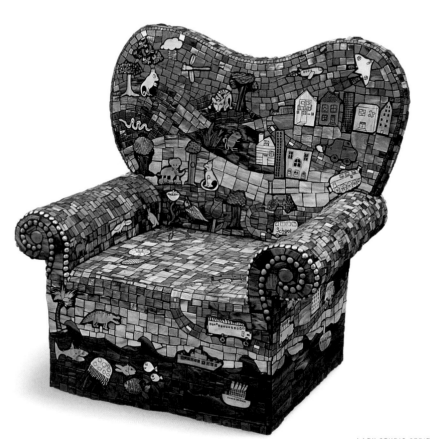

R.A. Laufer

## SPLIT-BACK COUNTER CHAIR
37 x 20 x 23 inches (93 x 51 x 58 cm)

Cherry

PHOTO BY BOB BARRETT

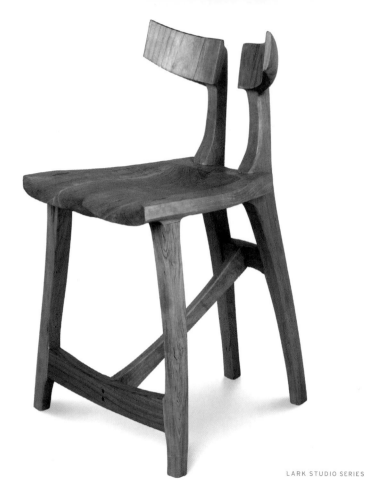

Todd Ouwehand

## CANTILEVERED ELLIPSES
28 x 22 x 24 inches (71 x 56 x 61 cm)

Purpleheart, silk upholstery

PHOTO BY MARK ADAMS

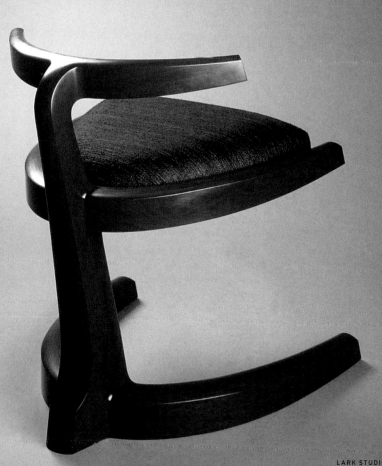

Mordechai Schleifer

## THE ORACLES' ARM CHAIR
30 x 39 x 31 inches (75 x 98 x 78 cm)

Mahogany, aluminum, stainless steel, velvet

PHOTO BY JONATHAN RACHLINE

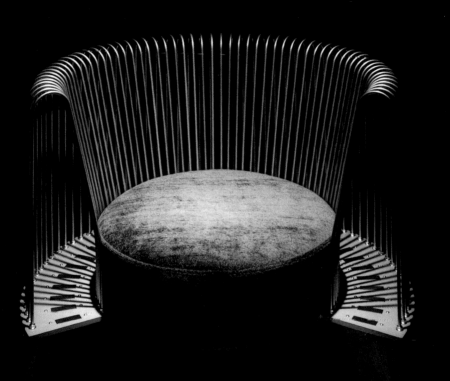

Kerry Marshall

## BORDEAUX CHAIR
36 x 20 x 24 inches (90 x 50 x 60 cm)

Recycled white oak wine barrel staves

PHOTO BY ARTIST

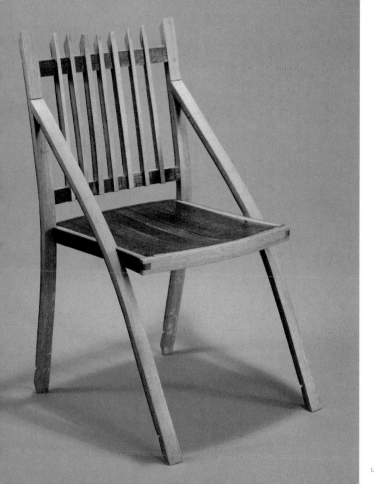

Howard Werner

## EUCALYPTUS CHAIR
46 x 45 x 48 inches (115 x 113 x 120 cm)

Eucalyptus

PHOTO BY ARTIST

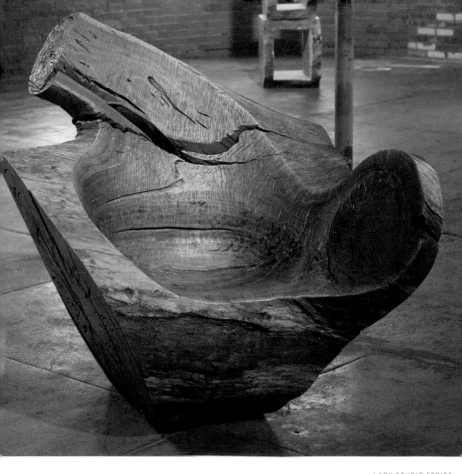

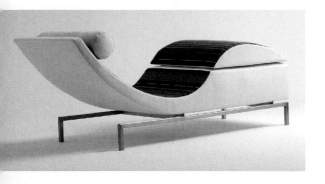

Daniel Kopec

# CHAISE
24 x 24 x 68 inches (61 x 61 x 170 cm)

Stainless steel, wool upholstery

PHOTOS BY DAVID WILLIAMS

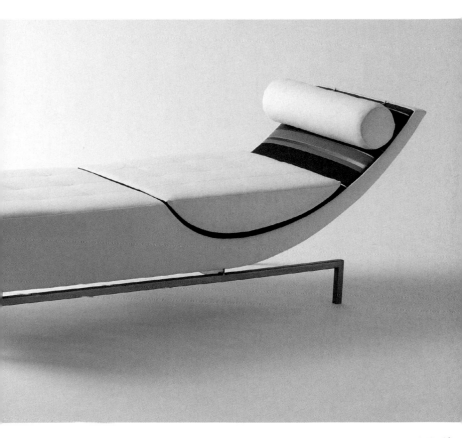

Sam Batchelor

# UNTITLED
36 x 62 x 24 inches (90 x 155 x 60 cm)

Bubinga, steel

PHOTOS BY ARTIST

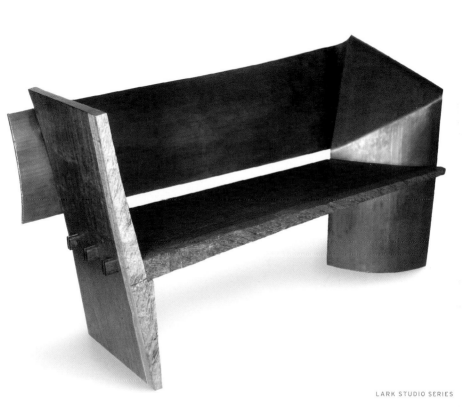

Sue Roberts

# SPIRAL BACK CHAIR
46 x 27 x 20 inches (115 x 66 x 50 cm)

Marine plywood, fir, acrylic paint

PHOTO BY ARTIST

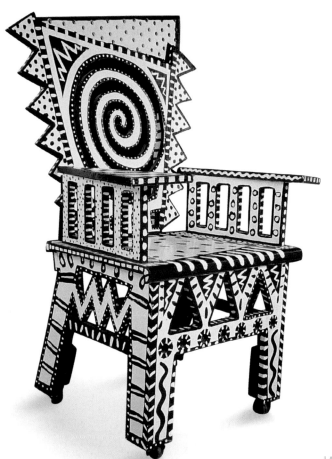

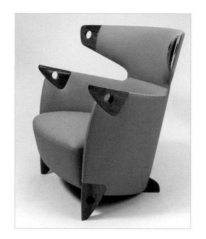

Alphonse Mattia

# FETISH CHAIR
35 x 42 x 27 inches (88 x 105 x 69 cm)

Russian plywood, various hardwoods, bubinga, vinyl

PHOTOS BY ERIK GOULD

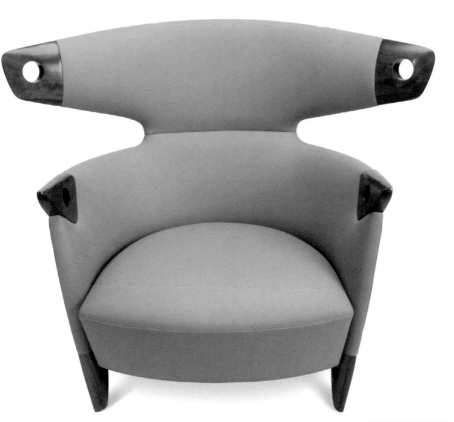

Janice C. Smith

## WHIMCYCLE
31 x 53 x 27 inches (78 x 133 x 68 cm)

Plywood, steel tubing, rubber wheels, upholstery

PHOTO BY REUBEN WADE

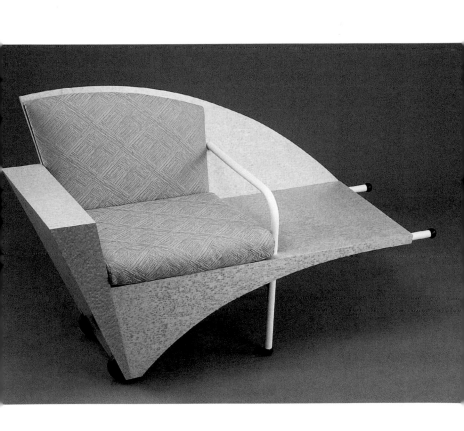

Michael Puryear

# BARROW CHAIR
32 x 29 x 28 inches (80 x 73 x 71 cm)

Bubinga, leather

PHOTO BY ARTIST

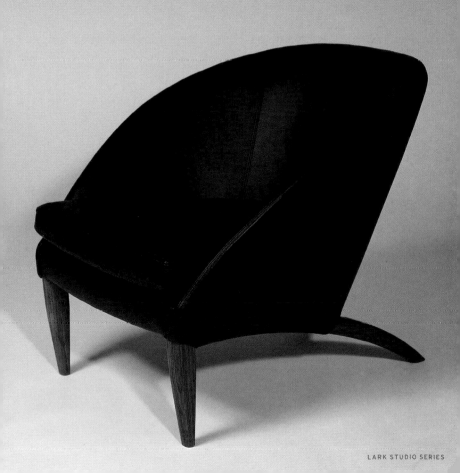

Susan Borger

## CATERPILLAR CONCENTRICS WITH FRINGE
34 x 19 x 14 inches (85 x 48 x 36 cm)

Reclaimed chair, cotton fabrics

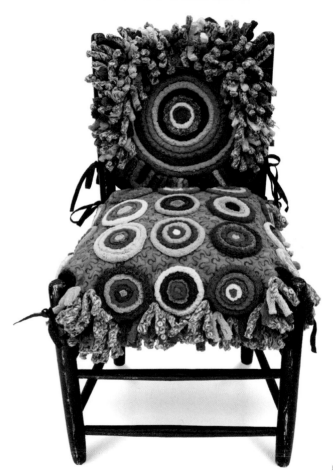

Alan Bradstreet

## WILLOW CHAIR
53 x 33 x 30 inches (133 x 83 x 75 cm)

Willow, aspen

PHOTO BY DENNIS GRIGGS

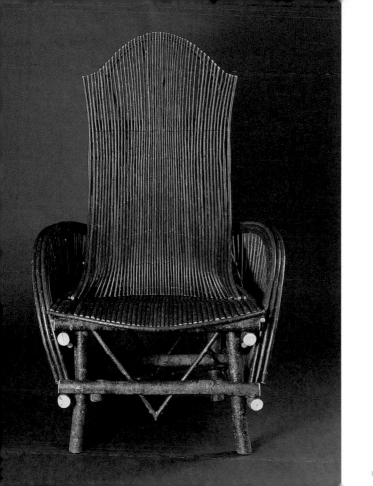

Thomas Hucker

## ROCKER
37 x 22 x 23 inches (93 x 56 x 58 cm)

White oak

PHOTO BY LYNTON GARDNER

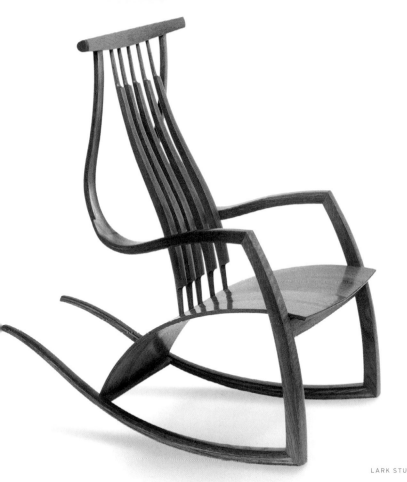

Isaac Arms

## STEEL CHAIR
30 x 28 x 45 inches (75 x 70 x 113 cm)

Steel, patina, powder coating

PHOTO BY BILL LEMKE

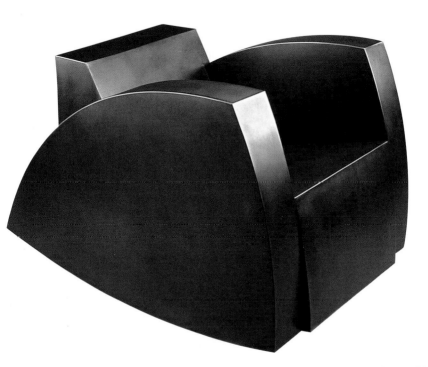

Garry Knox Bennett

# NEW LADDERBACK
42 x 15 x 22 inches (105 x 38 x 56 cm)

Wood, fabricated ladder

PHOTOS BY M. LEE FATHERREE

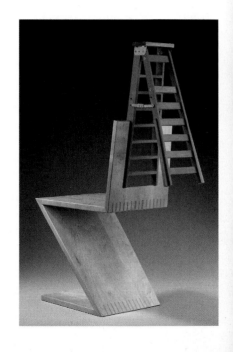

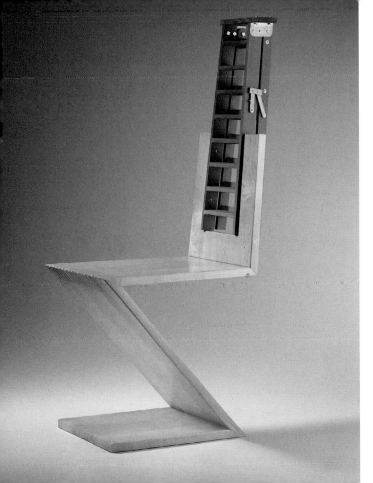

Tom Loeser

# LADDERBACKKCABREDDAL
Each: 87 x 41 x 21 inches (218 x 103 x 53 cm)

Wood, paint

PHOTO BY BILL LEMKE

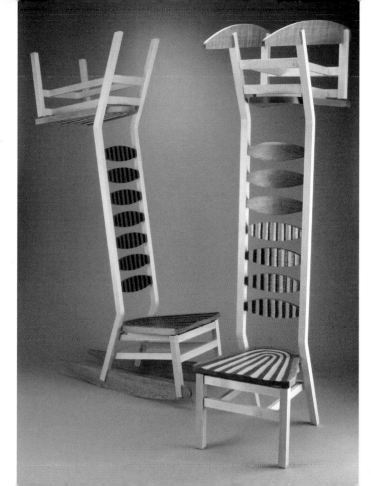

Gregory Lavoie

# ARTHROPOD
31 x 18 x 36 inches (78 x 46 x 90 cm)

Baltic birch, plywood

PHOTOS BY ARTIST

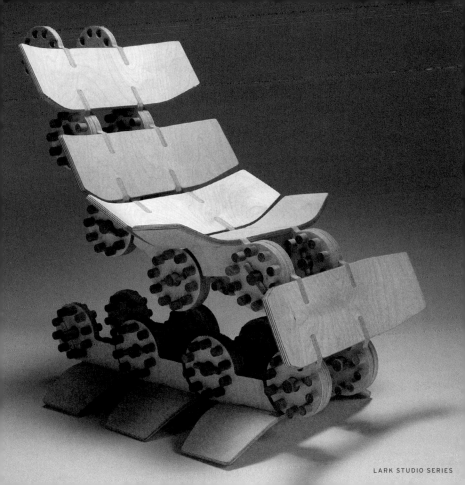

LARK STUDIO SERIES

Gord Peteran

**ARK**
66 x 26 x 48 inches (165 x 65 x 120 cm)

Wood, bronze, glass, velvet

PHOTO BY ELAINE BRODIE

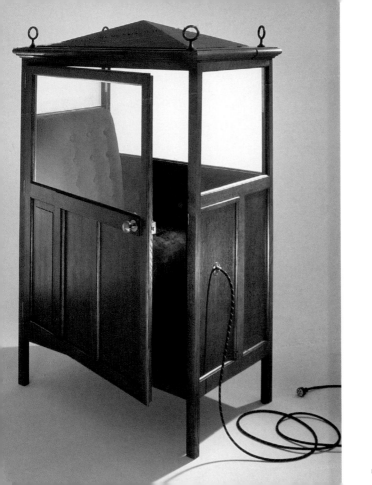

Susan R. Ewing

## SERIE ARQUITECTONICA: FOLDED CHAIR II

44 x 22 x 20 inches (110 x 56 x 50 cm)

Aircraft aluminum

PHOTOS BY JEFFREY SABO

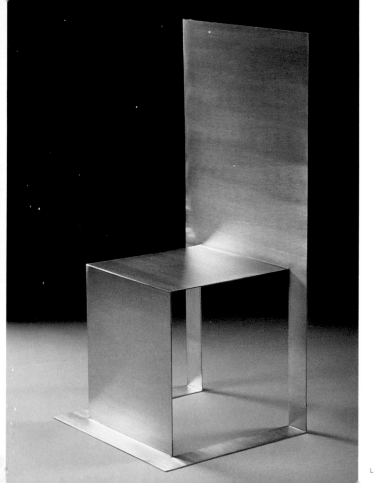

Liz Kerrigan

## AFTER YOU (NO. 1)
40 x 15 x 16 inches (100 x 38 x 41 cm)

Steel, plate glass

PHOTO BY JOSEPH SAVANT

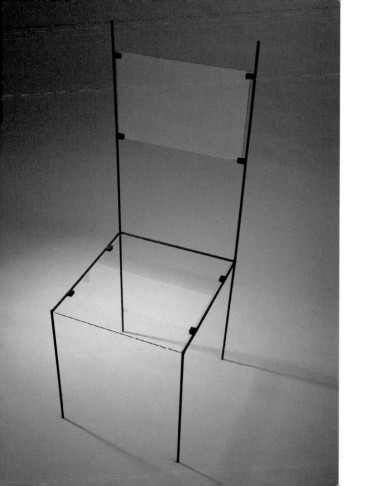

Peter Fleming

## BURNT CHAIR

32 x 18 x 17 inches (80 x 46 x 43 cm)

Cast urethane

PHOTO BY ARTIST

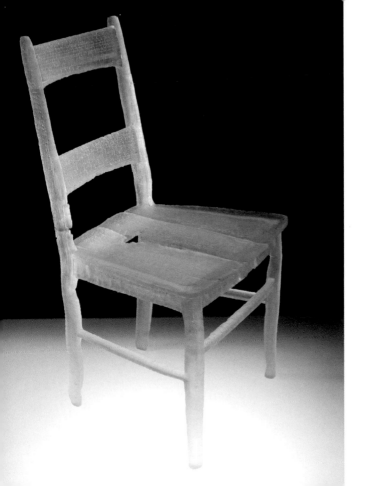

Jennifer Anderson

## CONVERSATION
30 x 20 x 19 inches (75 x 51 x 48 cm)

Stainless steel, fiberglass, leather

PHOTO BY LARRY STANLEY

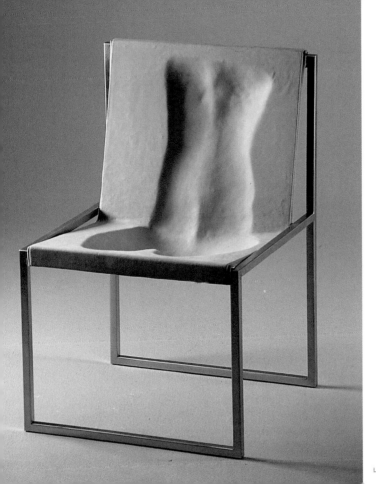

Wharton Esherick

## WAGON WHEEL CHAIR
40 x 25 x 24 inches (100 x 64 x 61 cm)

Ash, hickory fellows and shafts, harness leather

PHOTO BY MANSFIELD BASCOM
COURTESY OF WHARTON ESHERICK MUSEUM

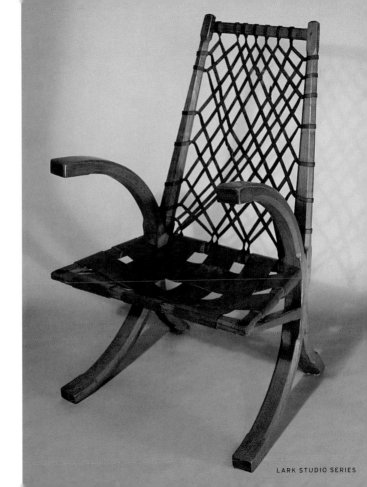

# ARTIST INDEX

**HUCKER, THOMAS**
Jersey City, New Jersey 180

**KELZER, KIM**
Freeland, Washington 120

**KERRIGAN, LIZ**
Dallas, Texas 194

**KOPEC, DANIEL**
Clifton, New Jersey 164

**LARIMORE, JACK**
Philadelphia, Pennsylvania 30

**LAUFER, R. A.**
Parkton, Maryland 154

**LAVOIE, GREGORY**
Red Creek, Alberta, Canada 188

**LEPO**
Lima, Ohio 146

**LEVATHES, CONNIE**
San Francisco, California 152

**LEWIS, DALE**
Oneonta, Alabama 50

**LIPTON, GREGG**
Cumberland, Maine 98

**LOESER, TOM**
Madison, Wisconsin 186

**MALOOF, SAM**
Altaloma, California 10

**MARSHALL, KERRY**
Mendocino, California 160

**MATTIA, ALPHONSE**
Indiana, Pennsylvania 170

**MCKIE, JUDY KENSLEY**
Cambridge, Massachusetts 86

**MERCADO, ROSARIO**
San Diego, California 76

**MILLARD-MENDEZ, ROB**
Evansville, Indiana 26

**MODERBACHER, NIKOLAI**
Brooklyn, New York 68

**MONTEITH, CLIFTON**
Lake Ann, Michigan 116

**MUGGLETON, ANDREW**
Longmont, Colorado 52

**MUJTABA, SABIHA**
Clarkston, Georgia 122

**NAUMAN, MATTHEW E.**
Frederick, Maryland 44

**NELSON, BRAD REED**
Carbondale, Colorado 96

**NUTT, CRAIG**
Kingston Springs, Tennessee 14

**OLIVIER, JUDIYABA**
Sebastopol, California 32

**OLIVIER, RUFUS**
Sebastopol, California 32

**ORTEGA, KATHERINE**
San Diego, California 24

**OUWEHAND, TODD**
Los Angeles, California 156

**PAPAY, MARCUS**
Camarillo, California 42

**PELCAK, B.G.**
St. Louis, Missouri 64

**PEŘINA, PAVEL P.**
Sob ě Šovice, Czech Republic 118

**PETERAN, GORD**
Toronto, Ontario, Canada 190

**POEHLMANN, CHRISTOPHER**
Fox Point, Wisconsin 80

**PULVER, DEAN**
El Prado, New Mexico 8

**PURYEAR, MICHAEL**
Shokan, New York 174

**REIBER, PAUL**
Mendocino, California 6

**ROBERTS, SUE**
Guemes Island, Washington 168

**ROBLES, VINCENT**
Atascadero, California 112

**ROSENTHAL, SYLVIE**
Asheville, North Carolina 78

**RYERSON, MITCH**
Cambridge, Massachusetts 142

**RYU, TAEYOUL**
Henrietta, New York 40

**SAMSON, STEVEN T.**
Grand Rapids, Michigan 132

**SCHLEIFER, MORDECHAI**
Hod-Hasharon, Israel 158

**SCHLENTZ, DENNIS P.**
Ramona, California 34

**SCOTT, DAVID W.**
Asheville, North Carolina 88

**SHEA, CHRIS**
Brandywine, Maryland 136

**SINGER, MICHAEL**
Felton, California 60

**SMITH, JANICE C.**
Philadelphia, Pennsylvania 172

**SPANGLER, ROBERT**
Bainbridge Island, Washington 72

**SYRON, J.M.**
Rockport, Massachusetts 106

**TODD, CHRIS M.**
Conway, South Carolina 102

**VAN DYKE, CAMERON**
Grand Rapids, Michigan 20

**VESPER, KERRY**
Tempe, Arizona 104

**VOGEL, TED**
Portland, Oregon 74

**WERNER, HOWARD**
Shokan, New York 162

**WHYTE, JOHNNY**
Knoxville, Tennessee 94

**WILSON, DEAN**
Oakdale, Minnesota 134

**WINDELS, LOTHAR**
Newton, Massachusetts 70

**WINKLE, KIMBERLY**
Smithville, Tennessee 28

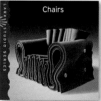